MEN
&
DOGS

Marie-Eva Chopin *and* Alice Chaygneaud

A TarcherPerigee Book

An imprint of Penguin Random House LLC
375 Hudson Street
New York, New York 10014

Most TarcherPerigee books are available at special quantity discounts for
bulk purchase for sales promotions, premiums, fund-raising, and
educational needs. Special books or book excerpts also can be
created to fit specific needs. For details, write:
SpecialMarkets@penguinrandomhouse.com.

Pages 105–106 constitute an extension of this copyright page.

ISBN 9780143132110

Printed in the United States of America

1 3 5 7 9 10 8 6 4 2

INTRODUCTION

Since we started our Tumblr, *Des Hommes et des Chatons*, in 2013, thousands of fans have discovered the allure of pairing sexy men with cute cats in strikingly similar poses.

But soon enough, dogs began to feel rather jealous and started a rebellion. They also wanted to be matched with some pretty boys.

Their dreams came true. We have created fifty never-before-seen man and dog couples. Now dog lovers (and man lovers) can see that their two favorite things are even better when paired together.

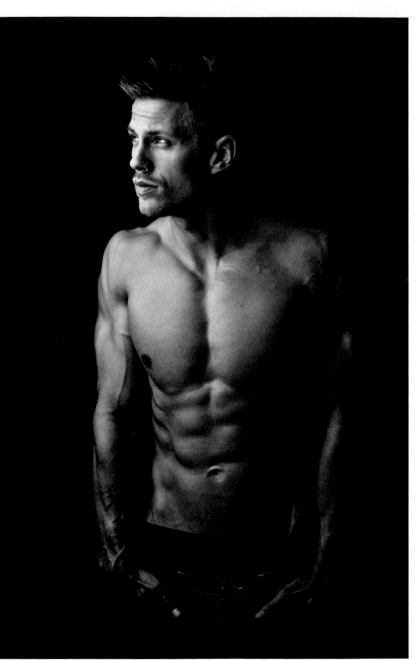

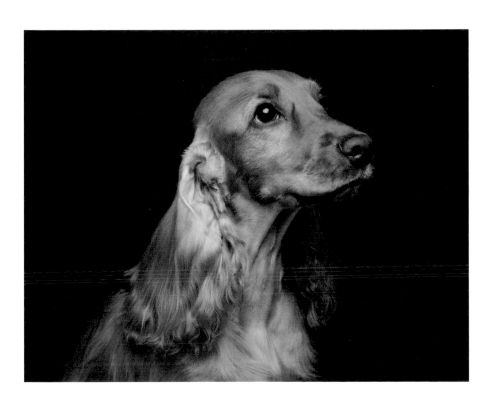

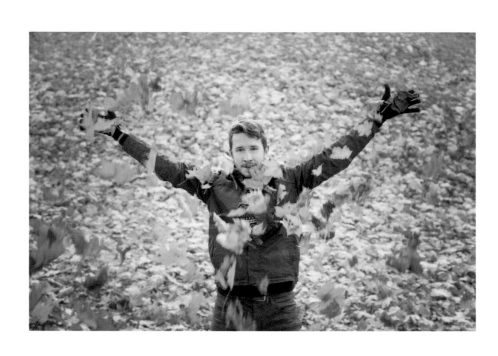

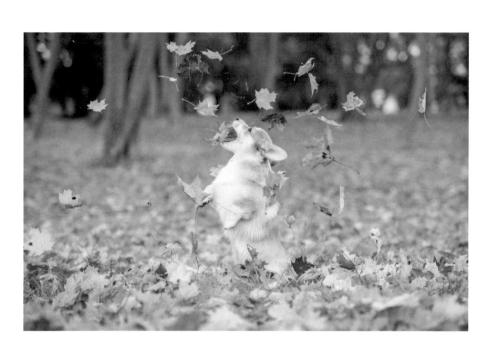

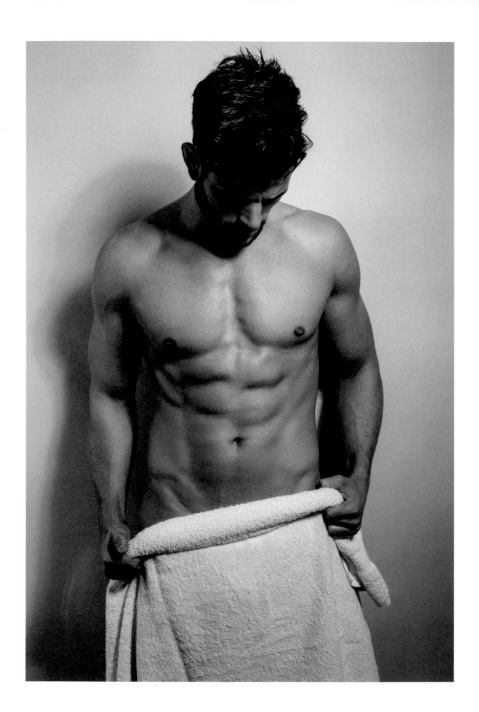

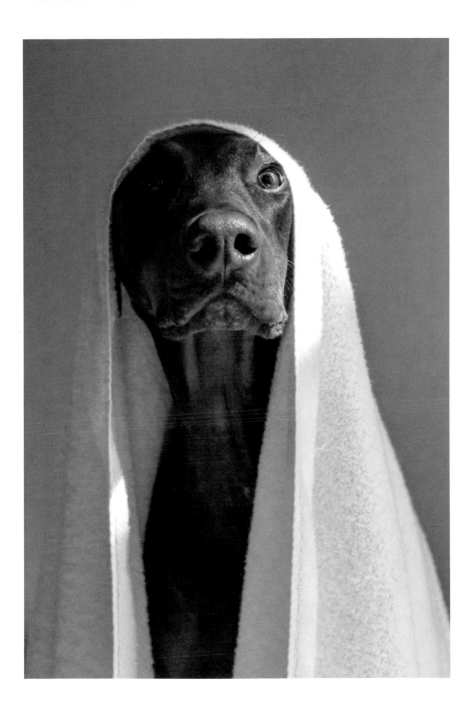

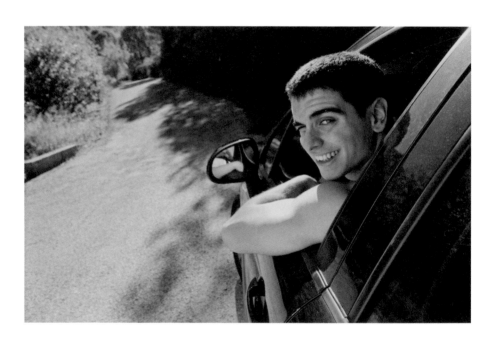

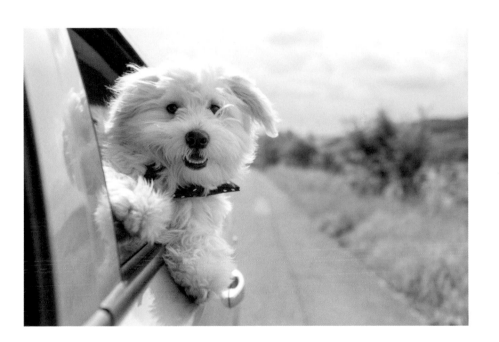

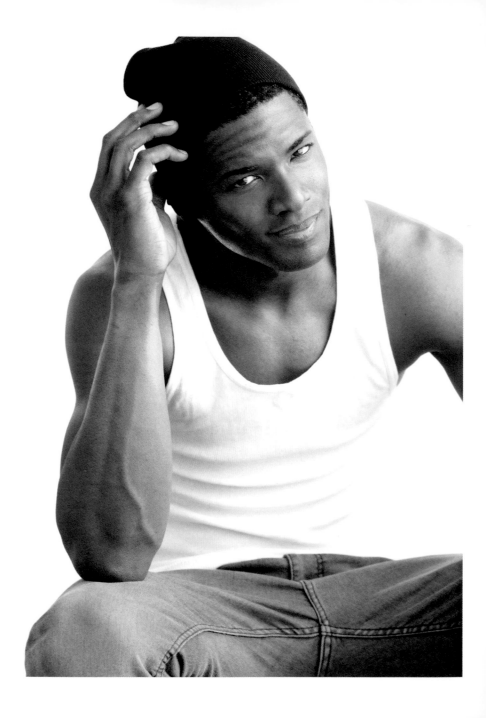

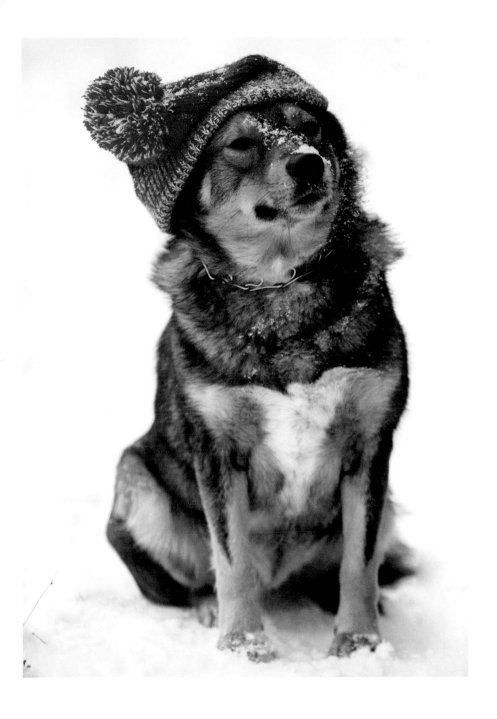

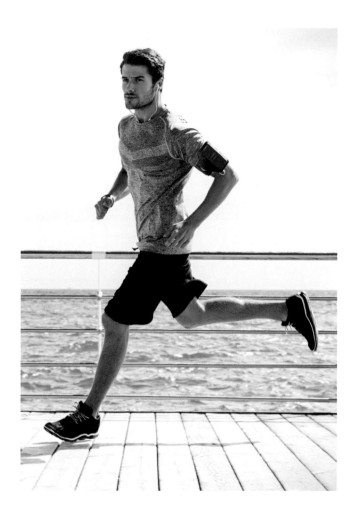

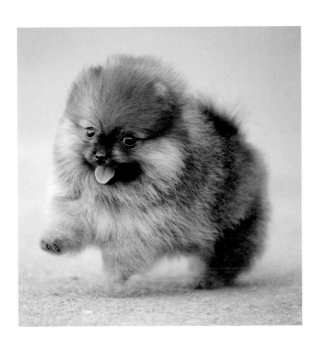

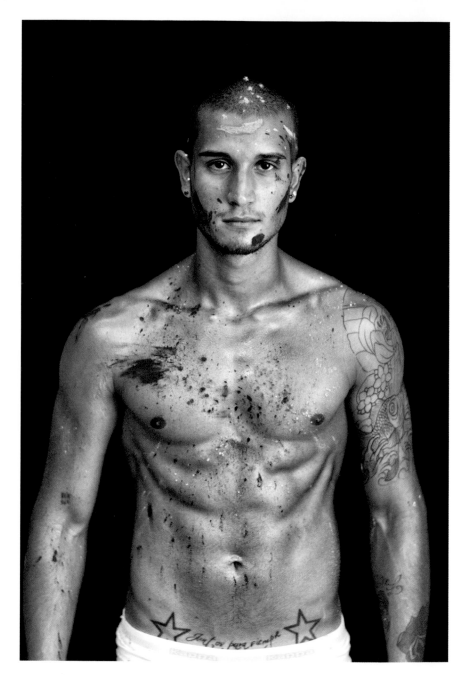

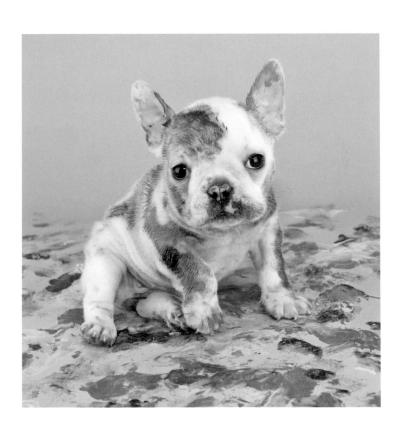

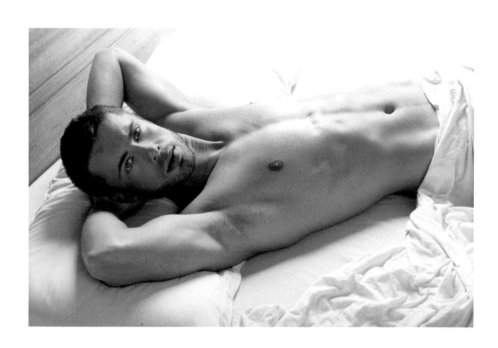

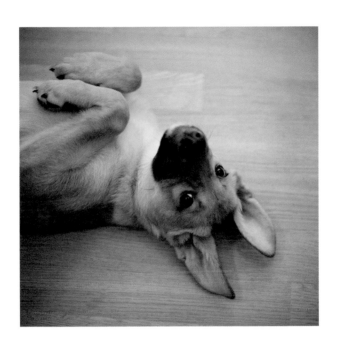

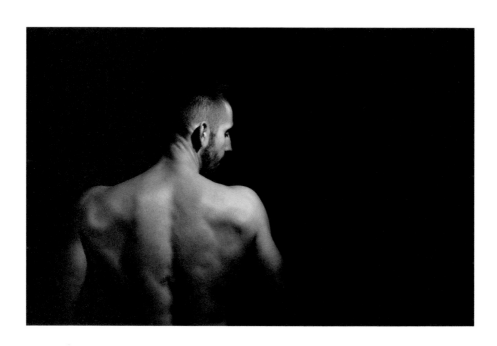

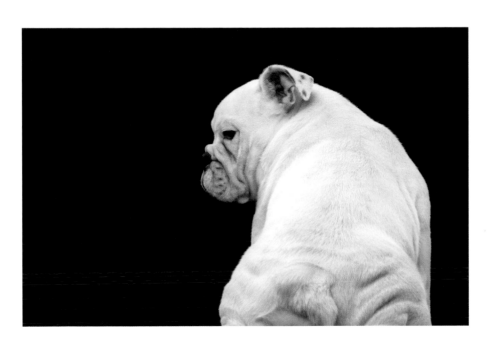

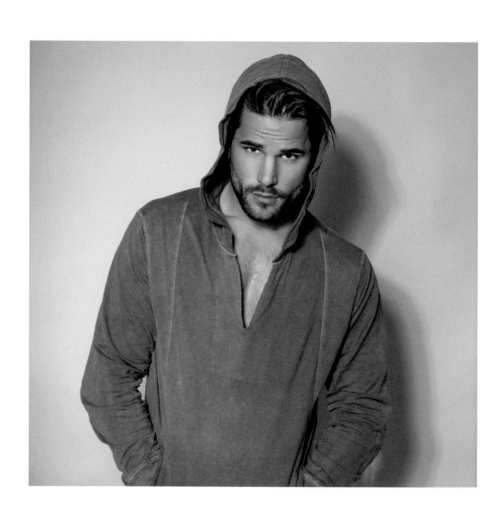

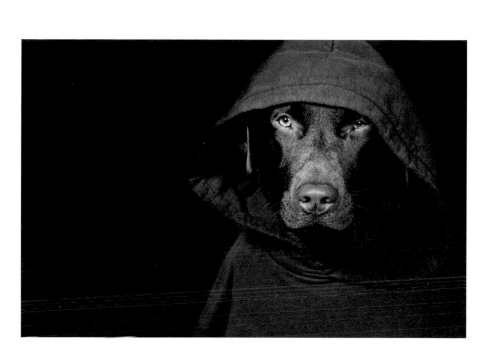

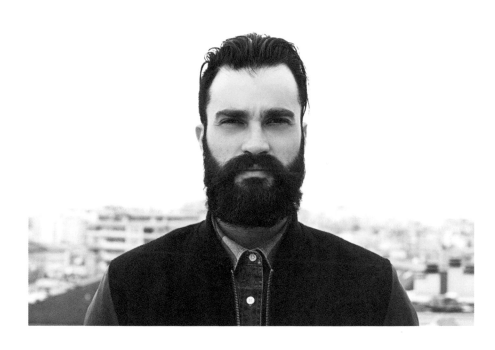

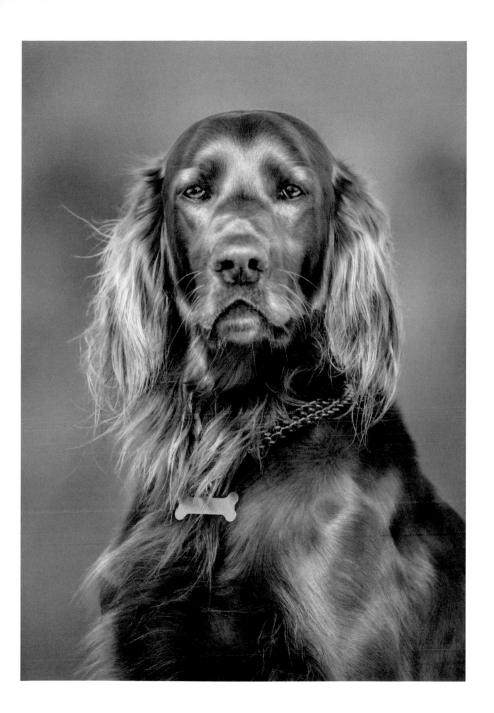

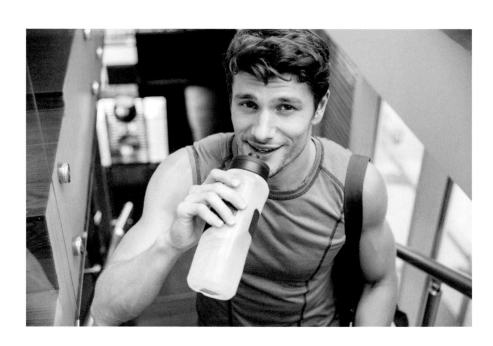

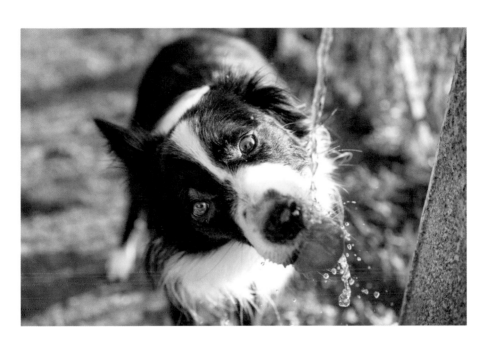

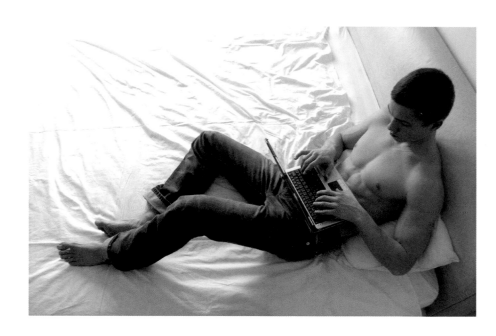

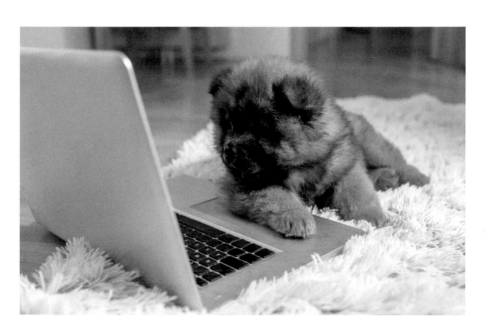

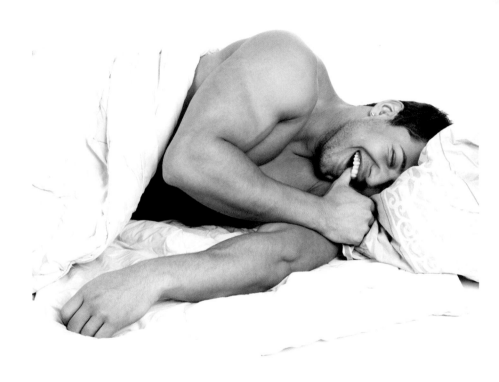

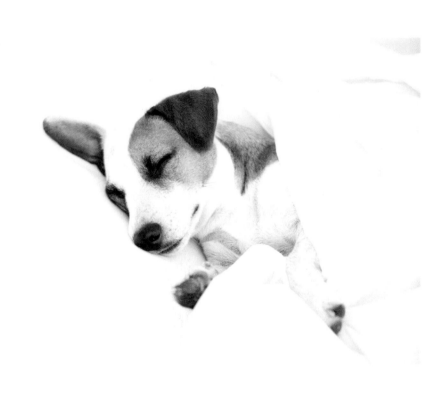

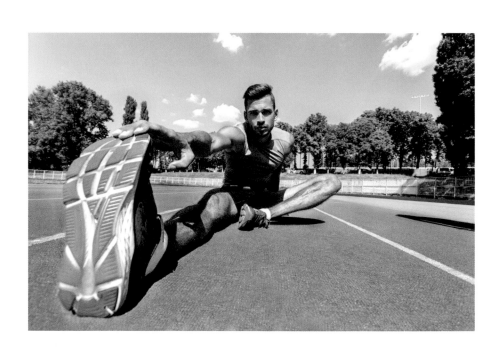

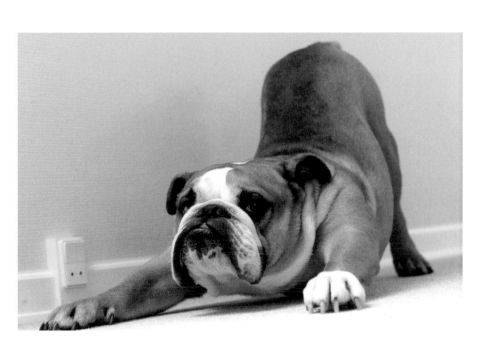

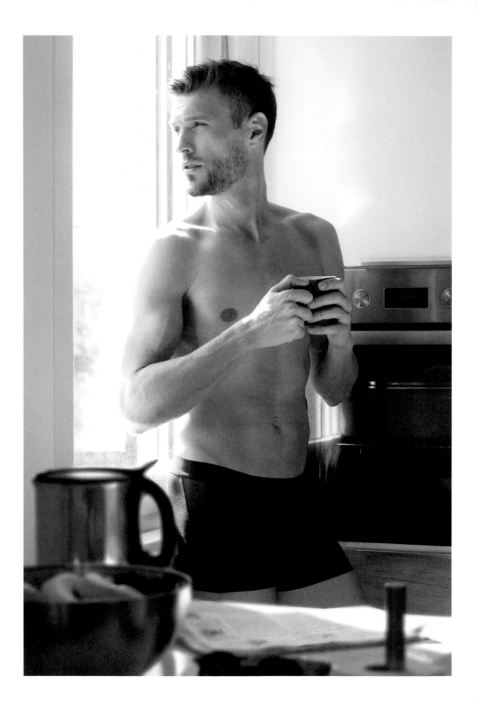

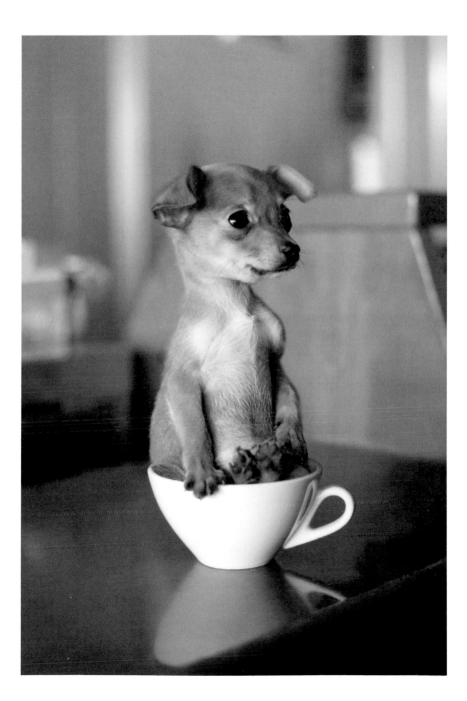

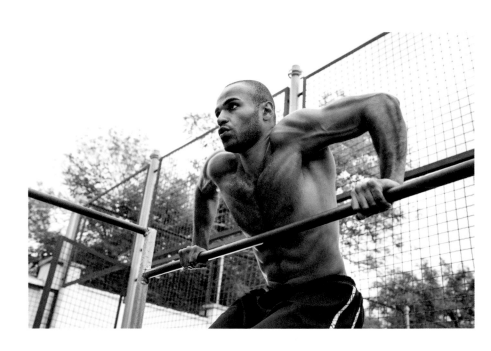

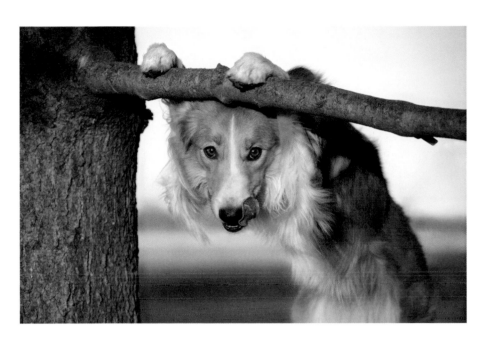

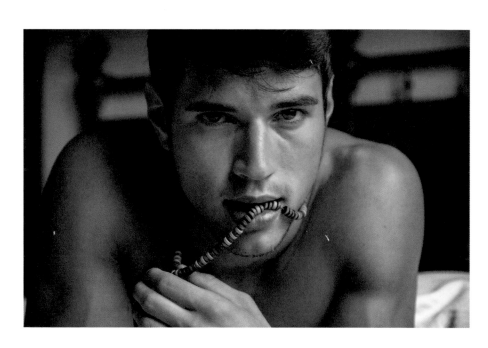

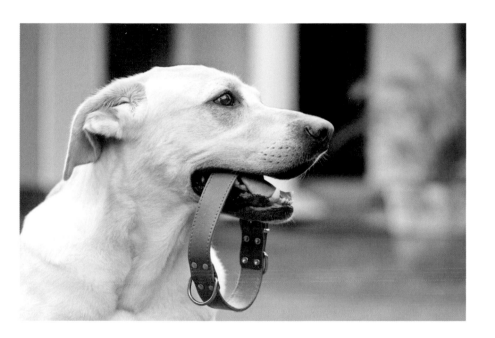

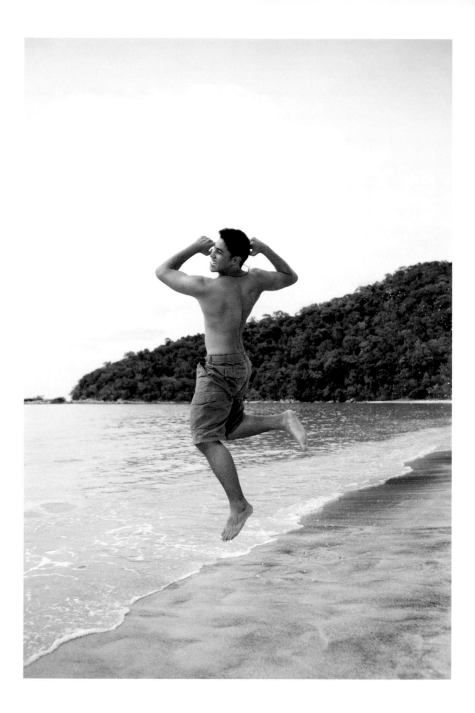

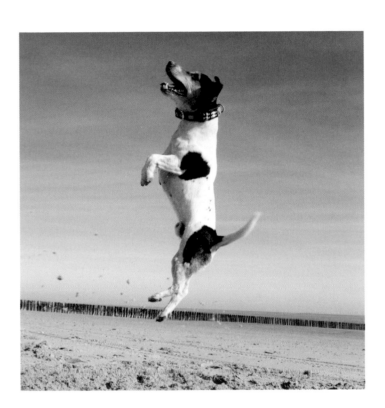

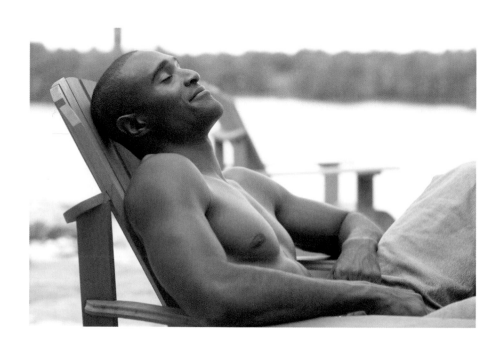

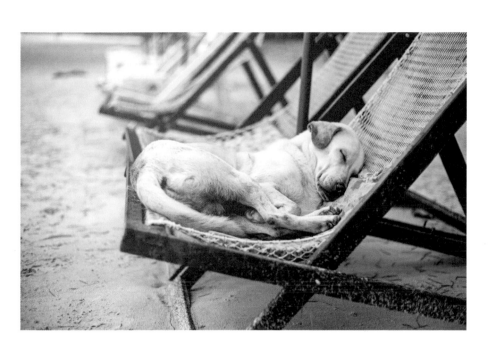

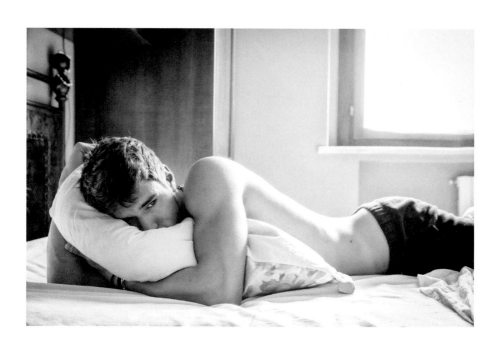

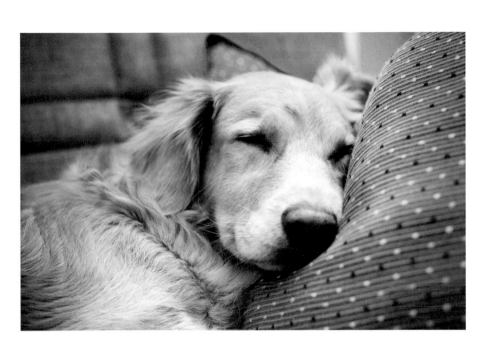

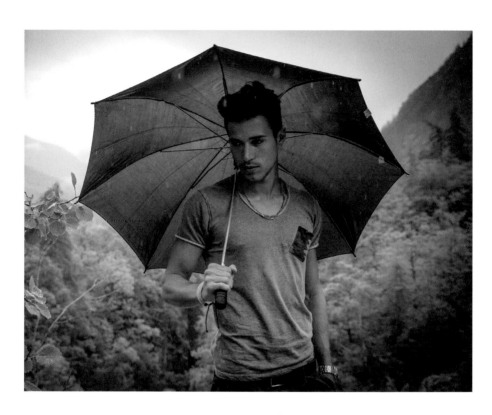

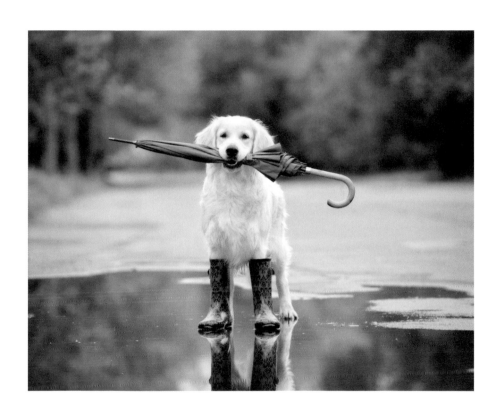

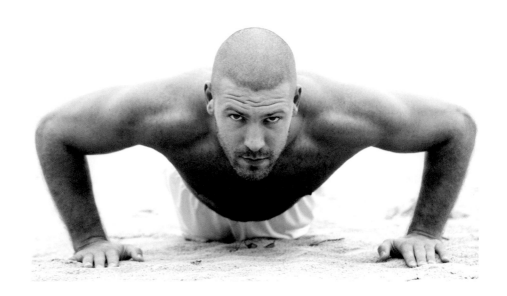

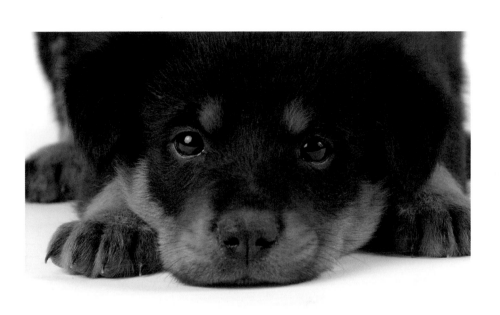

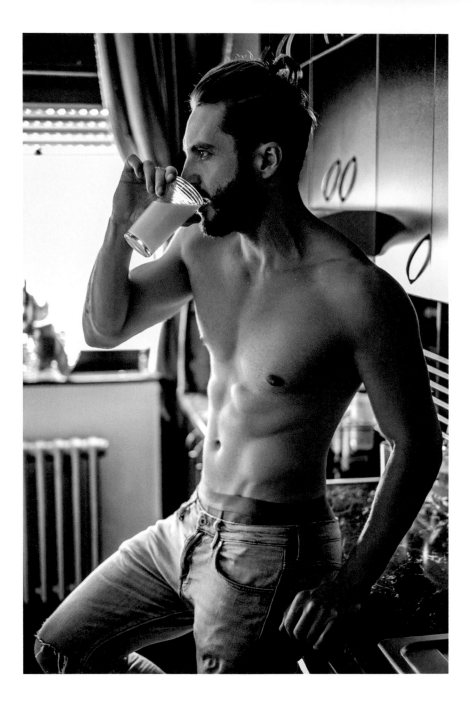

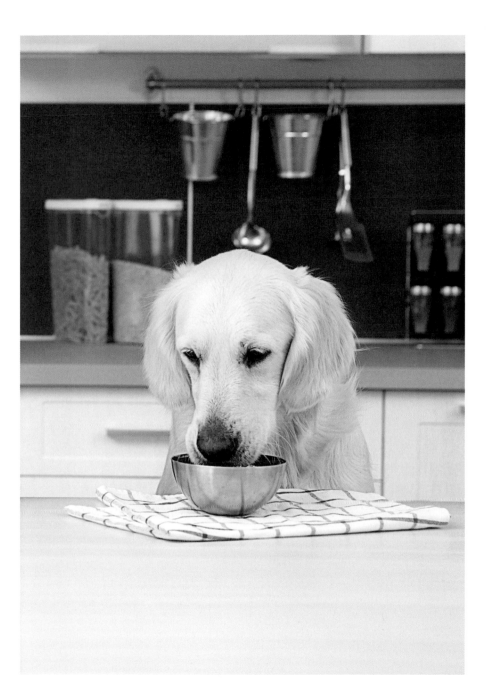

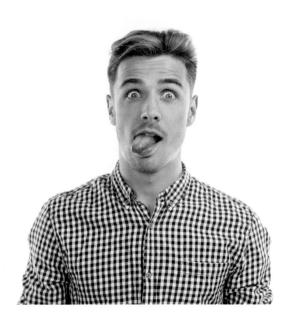

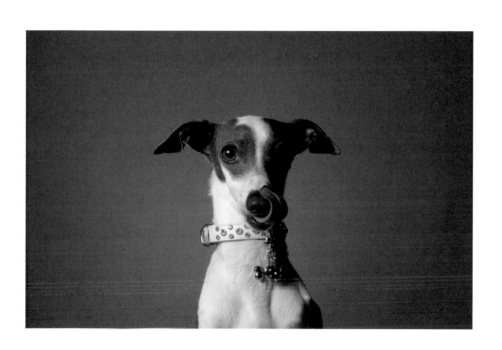

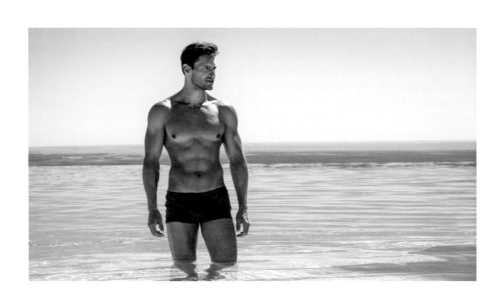

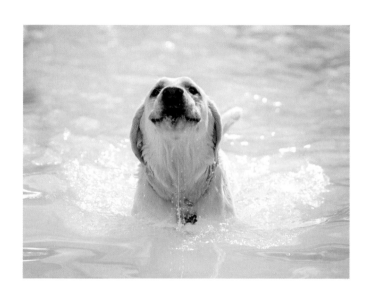

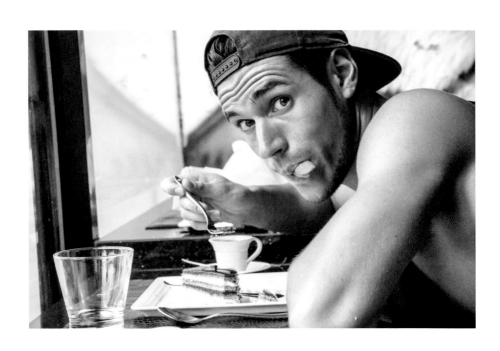

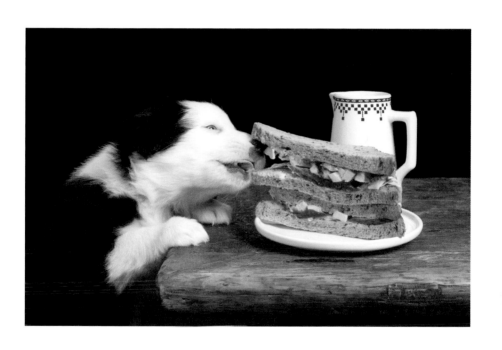

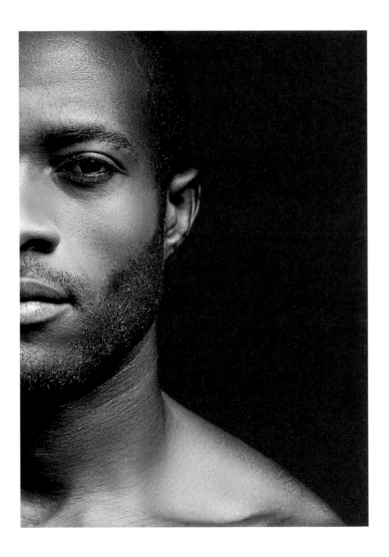

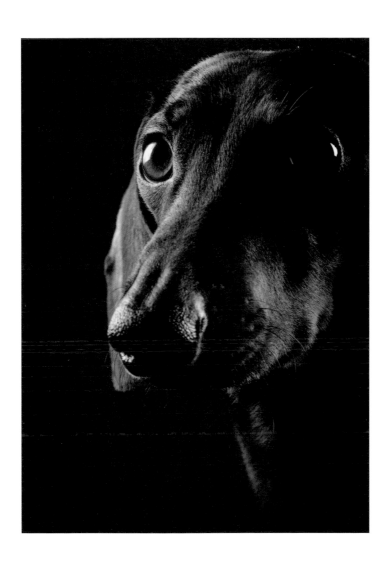

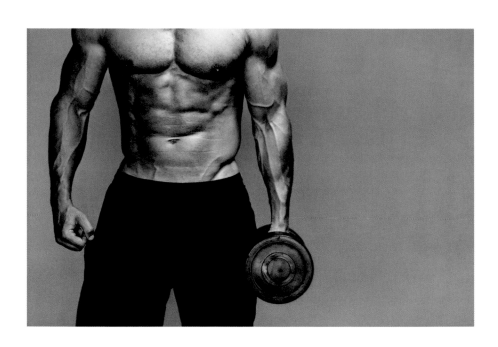

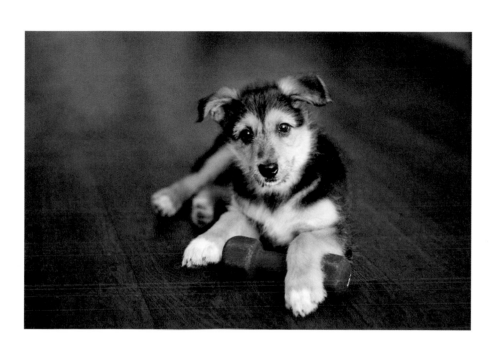

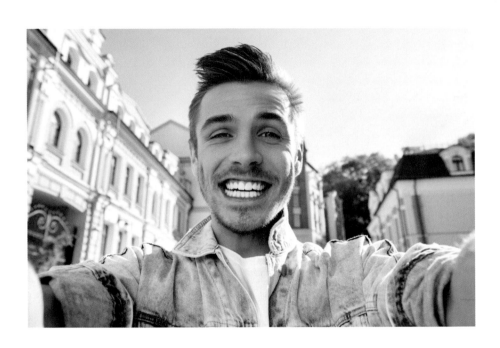

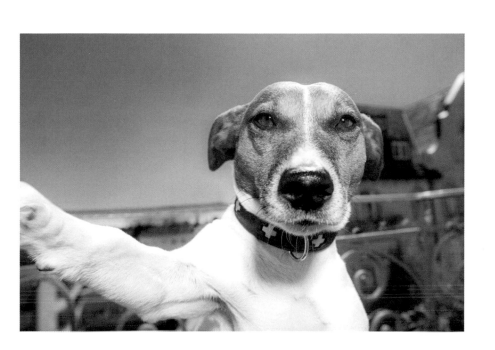

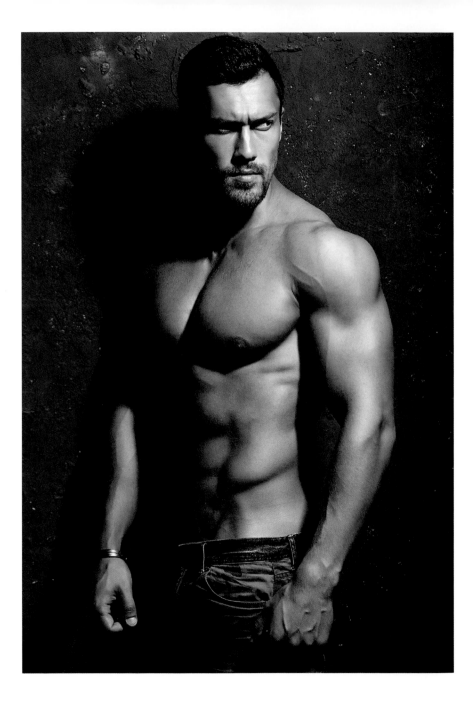

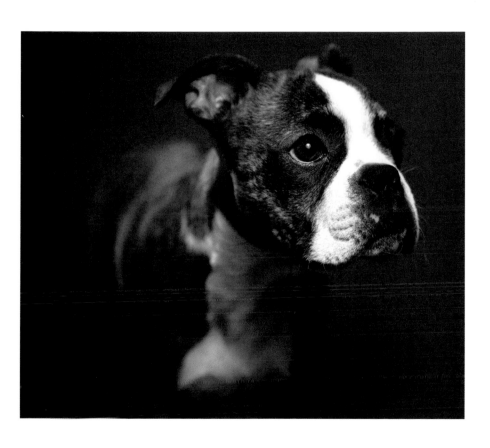

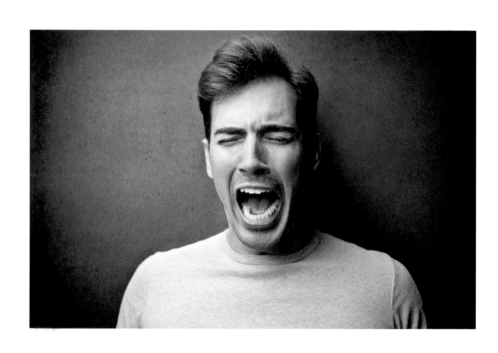

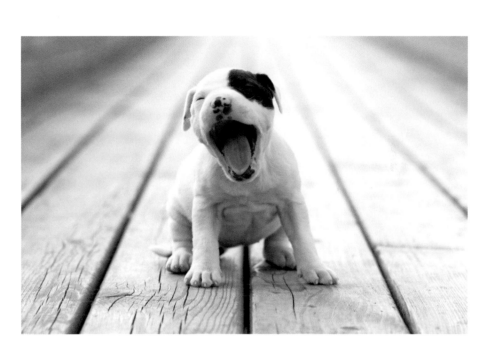

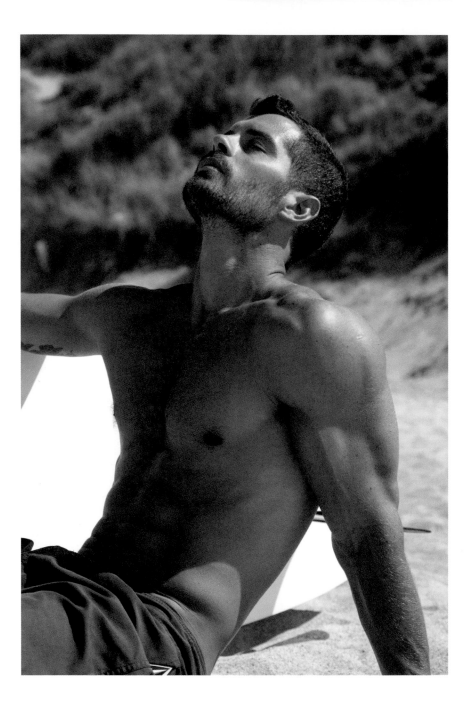

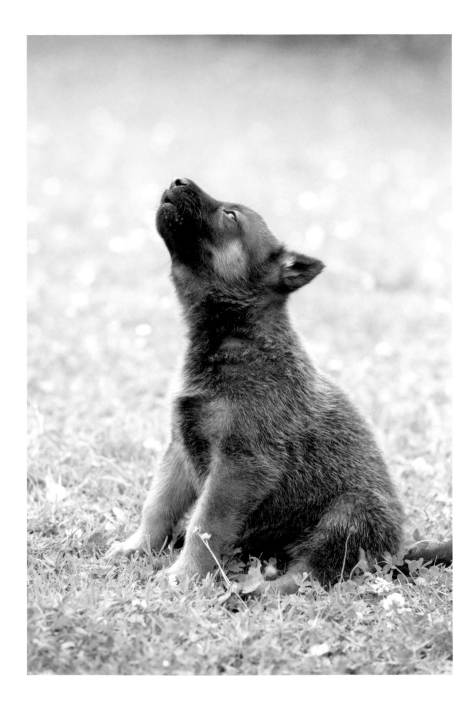

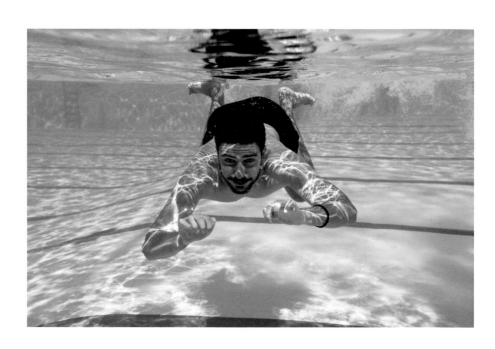

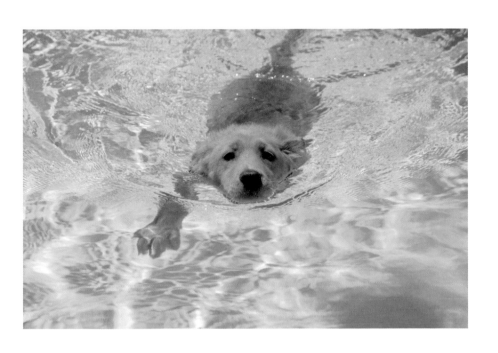

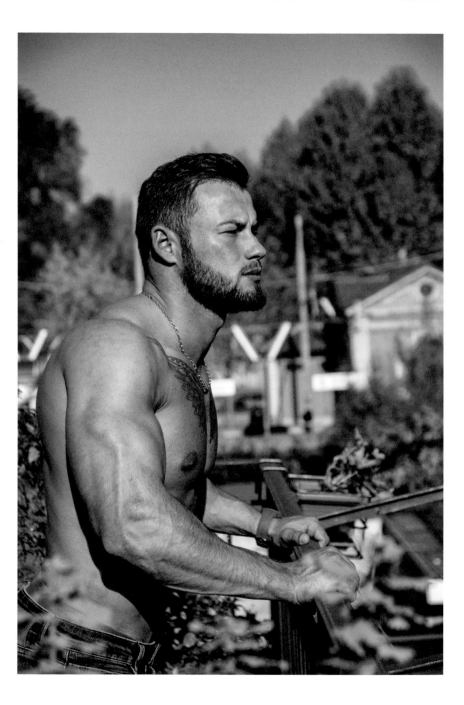

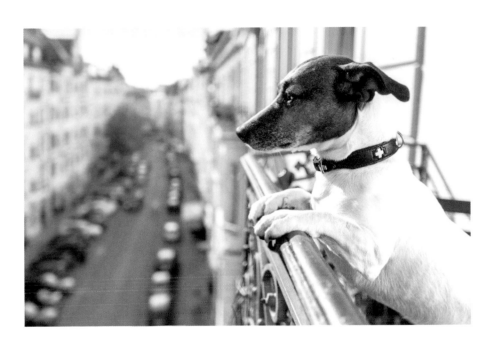

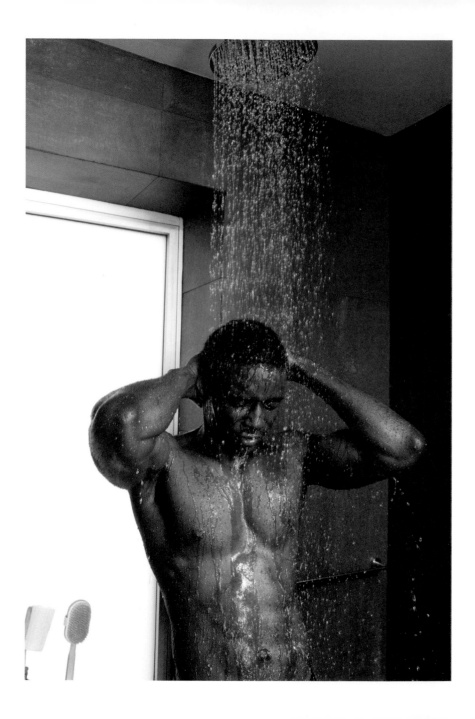

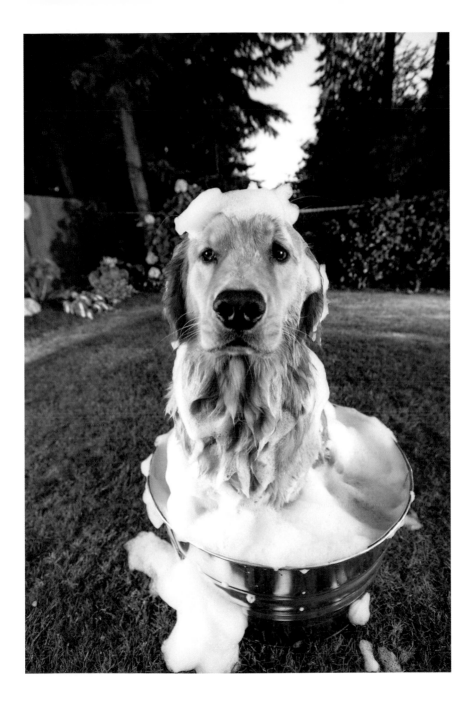

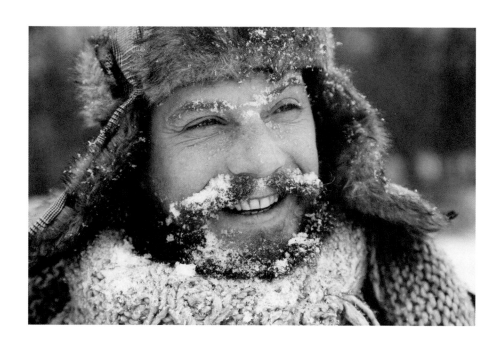

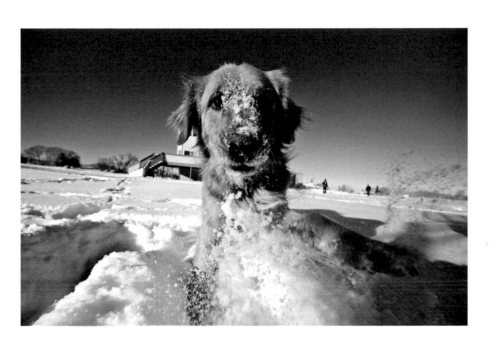

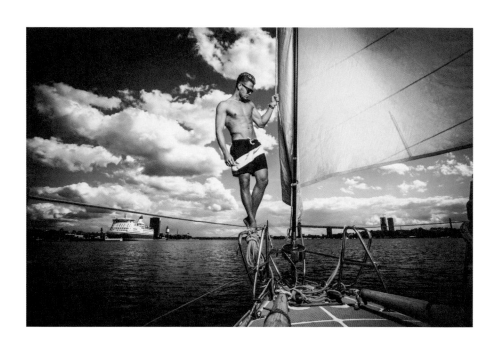

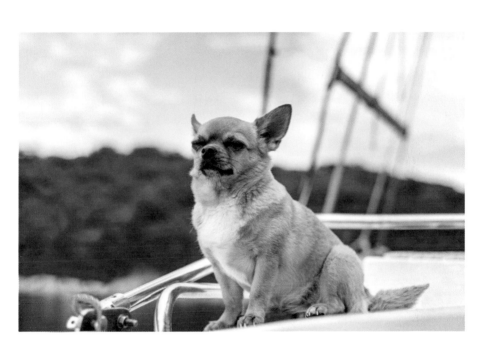

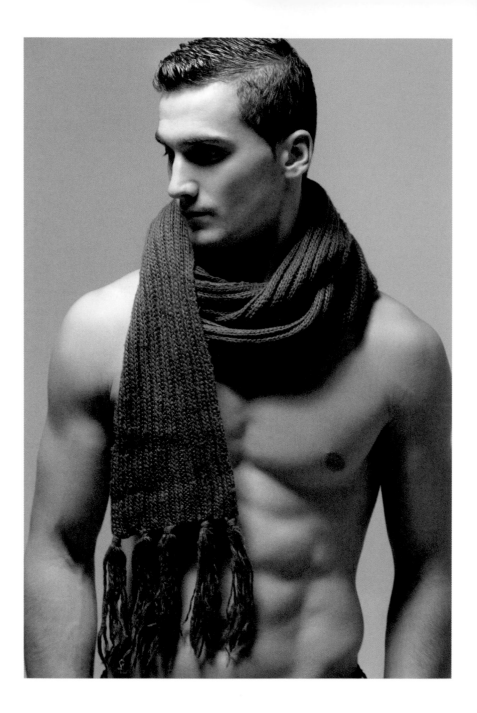

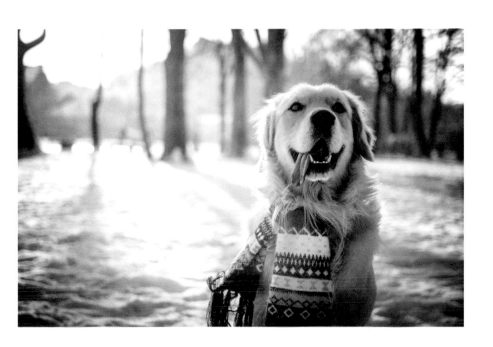

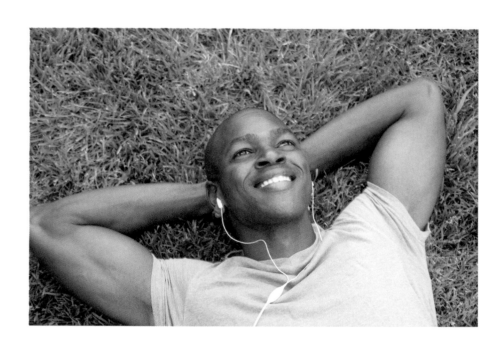

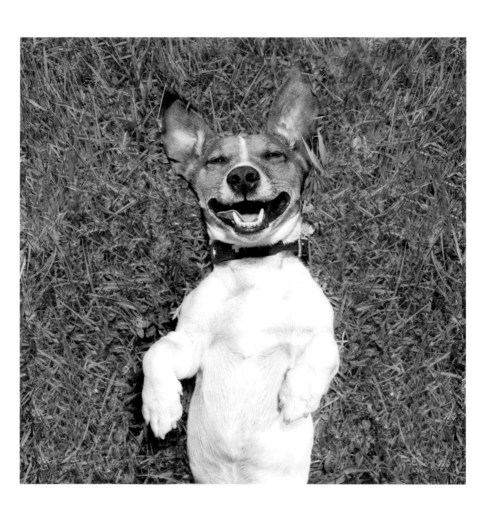

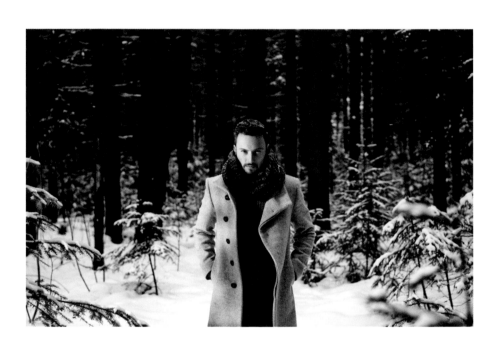

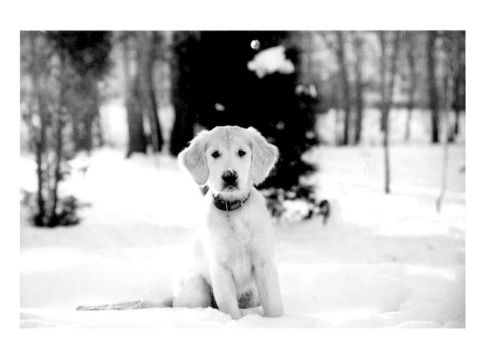

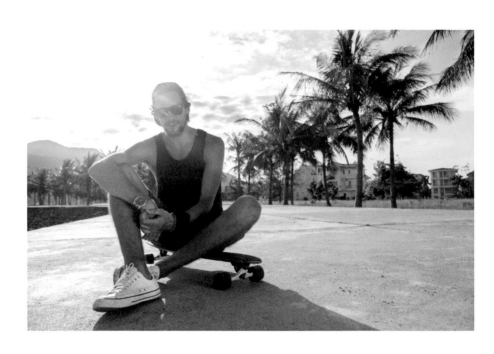

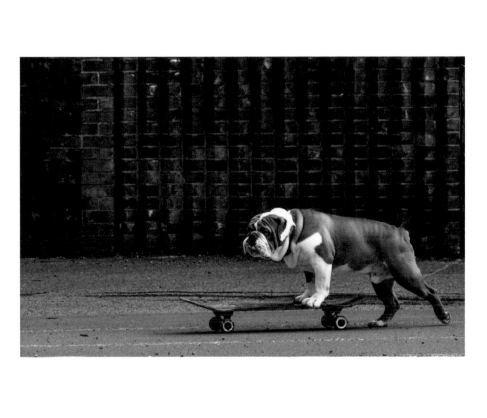

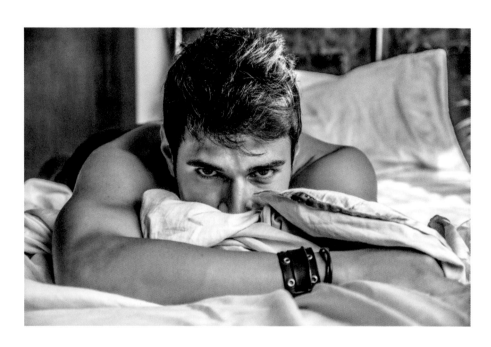

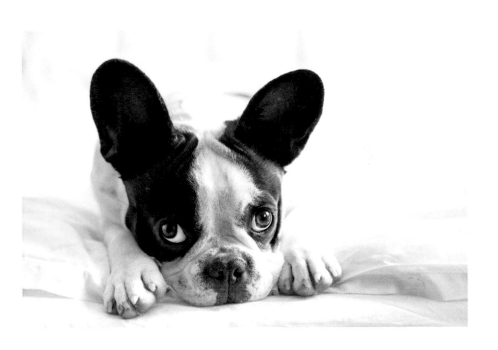

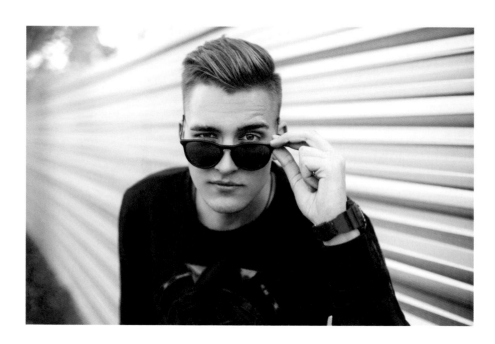

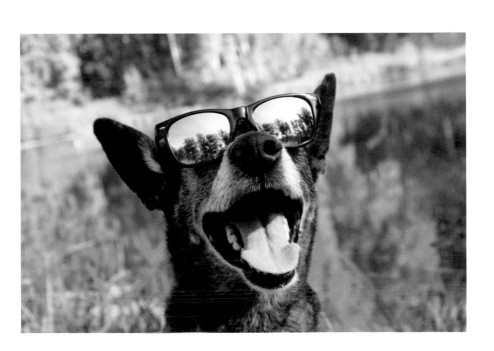

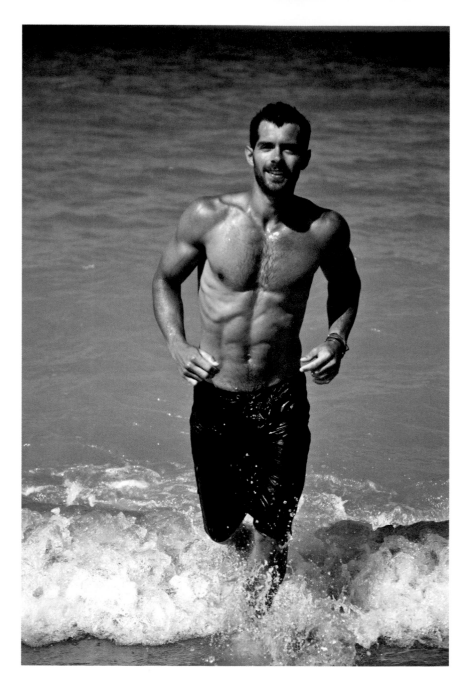

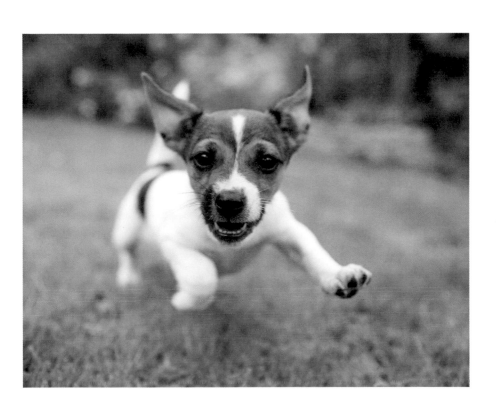

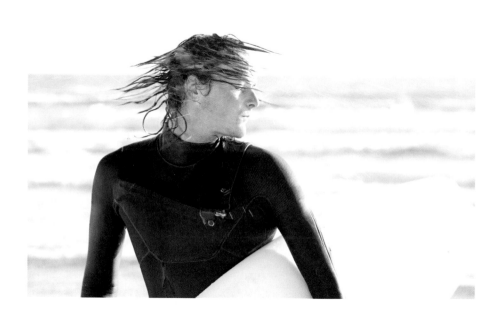

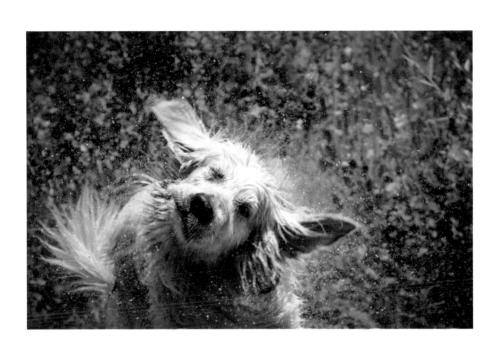

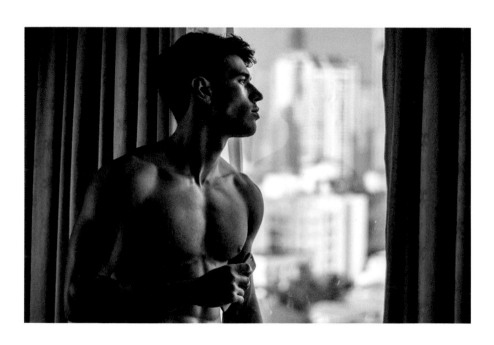

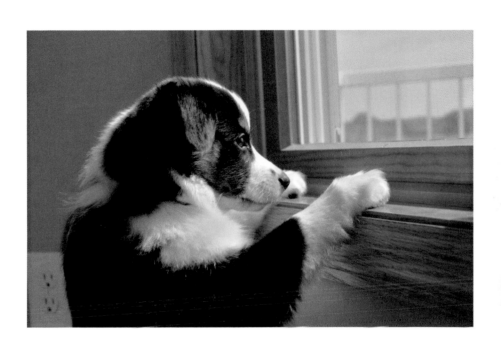

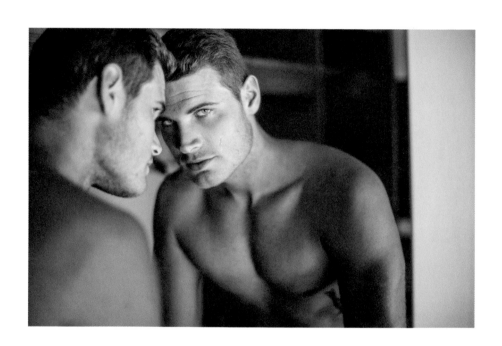

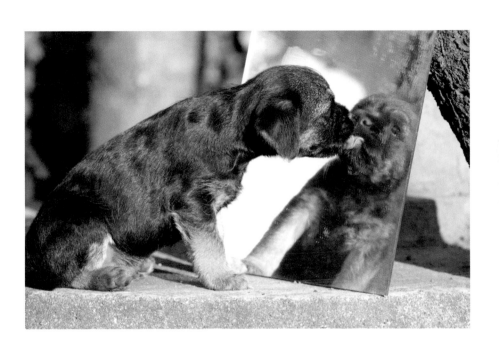

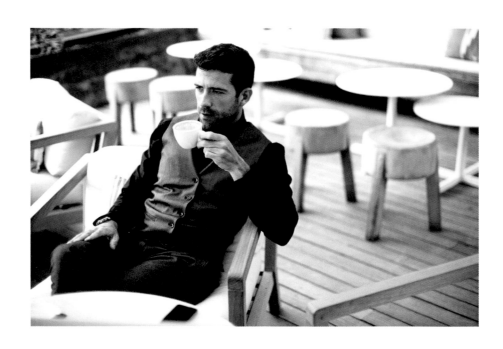

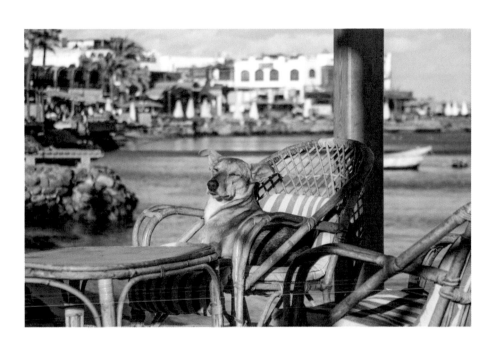

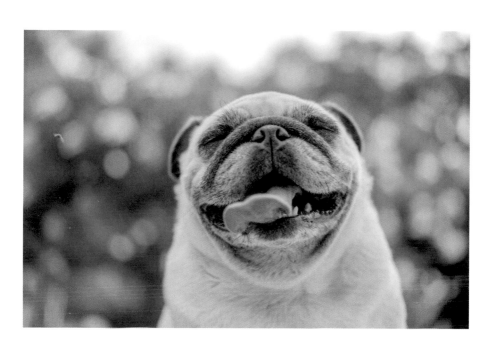

ACKNOWLEDGMENTS

We would like to thank our respective men, Michael and Simon, and the dogs in our lives: Zia (the setter), Diego (the galdo), Oscar (the dachshund), Peps (the spitz), Cooper (the border collie), and Claudine (the bosseron).

IMAGE CREDITS

Andreas Gradin/
 Shutterstock.com, 2
Svetography/Shutterstock.com, 3
FotoDuets/Shutterstock.com, 4
Grigorita Ko/Shutterstock.com, 5
anetta/Shutterstock.com, 6, 20
Victoria Rak/Shutterstock.com, 7
maxriesgo/Shutterstock.com, 8
LeventeGyori/Shutterstock.com, 9
CURAphotography/
 Shutterstock.com, 10
vvvita/Shutterstock.com, 11
Dean Drobot/Shutterstock.com, 1
 2, 24
Ksenia Raykova/Shutterstock.com,
 13, 35
Stefano Cavoretto/Shutterstock.com,
 14, 42, 44, 54, 70, 94
JStaley401/Shutterstock.com, 15
Phase4Studios/Shutterstock.com, 16
Elya Vatel/Shutterstock.com, 17
Vallo Zoltan/Shutterstock.com, 18
Seregraff/Shutterstock.com, 19
JPagetRFPhotos/
 Shutterstock.com, 21
SteLuk/Shutterstock.com, 22

Abramova Kseniya/
 Shutterstock.com, 23
oneinchpunch/Shutterstock.com, 25
Vladimir Wrangel/
 Shutterstock.com, 26
AkilinaWinner/iStock/
 Thinkstock, 27
FXQuadro/Shutterstock.com, 28
Gladskikh Tatiana/
 Shutterstock.com, 29
Nestor Rizhniak/
 Shutterstock.com, 30
Oleksandra Kuznietsova/
 Shutterstock.com, 31
Eviled/Shutterstock.com, 32
Stokkete/Shutterstock.com, 33
GlebStock/Shutterstock.com, 34
ArtOfPhotos/
 Shutterstock.com, 36
Jaromir Chalabala/
 Shutterstock.com, 37
eyedear/Shutterstock.com, 38
ghekko/iStock/Thinkstock, 39
Blend Images/Shutterstock.com, 40
pim pic/Shutterstock.com, 41
grki/iStock/Thinkstock, 43

ABOUT THE AUTHORS

Marie-Eva Chopin and **Alice Chaygneaud** are the founders of the popular Tumblr *Des Hommes et des Chatons*, which brings their two favorite things together: kittens and men. Every day they post a pair of photos, one man and one cat, with a shared posture or attitude. Both cute and sexy, the Tumblr reaches thousands of fans across the globe. Both authors live in Paris, France.